ANIMALS WITH SHARPIES

MICHAEL DUMONTIER & NEIL FARBER

Drawn & Quarterly

Hi MARILYN;
"CUTEFACE'S HUSBAND"
Allan Stotes
DEC. 19, 2013

MERRY CHRISTMAS,
MARILYN!
2013
Love Doug ANDERSON

"Happy Holidays"
Marilyn –
Take care,
P/o Nordmeyer

Wish you were here!
– We miss you.
Gail Anderson

Happy Xmas!
Anne + Dick Klein

HEY, MARILYN!
WE LOVE YOU!
MAY THE GOOD CHRISTMAS
ANGELS SMITE YOU BEAUTIFULLY!
♥ JACKIE

www.drawnandquarterly.com. First Hardcover edition: June 2013. 10 9 8 7 6 5 4 3 2 1; Printed in Malaysia. Library and Archives Canada Cataloguing in Publication: Dumontier, Michael, 1974–; *Animals with Sharpies /* Michael Dumontier and Neil Farber. ISBN 978-1-77046-106-2. 1. Animals—Comic books, strips, etc. 2. Graphic novels. I. Farber, Neil, 1975– II. Title. PN6733.D84A65 2013 741.5'971 C2012-905369-4. Published in the USA by Drawn & Quarterly, a client publisher of Farrar, Straus and Giroux; 18 West 18TH Street; New York, NY 10011; Orders: 888.330.8477. Published in Canada by Drawn & Quarterly, a client publisher of Raincoast Books; 2440 Viking Way; Richmond, BC V6V 1N2; Orders: 800.663.5714. Distributed in the United Kingdom by Publishers Group UK; 63-66 Hatton Garden; London; EC1N 8LE; info@pguk.co.uk. Drawn & Quarterly acknowledges the financial contribution of the Government of Canada through the Canada Book Fund and the Canada Council for the Arts for our publishing activities and for support of this edition.

I WAS BORN
WITHOUT ARMS
OR LEGS
PLEASE

TWO rODES dyvurjed
IN A yello wood and
Sory I cood NoT travle
both and be ONe travler
long I stood and loked
down one as Far as I

I have No best Friend becAUSE I'M wierd, so Now MY MOM is my best Friend AND MY WIFE is MY MOM and Now I just need A WIFE

MORE HANDSOME = MORE RANSOM

the conversation went some things right, this time. "you took while you aren't good, you aren't feeling well. It wasn't. Of course...

...gave to look at where you started from.

AND IS therefore unclean for you; and the PIG, which does indeed have hoofs and is cloven-footed, does Not chew the cud therefore unclean for you. Flesh you shall Not eat dead bodies you shall Not touch.

Leviticus, CHA

I, being unable to pay my debts as they became due, hereby assign and abandon all my property to the trustee, for the general benefit of my creditors.

My mom and I went shoping because we
Got our ~~bother~~ check we were hapy and
buy a computer games about were you make
people and they lives in a house and have a
problem and Either you help then or they die
and you can pick there cl

I DIDN'T COME FROM NO FROM NO MONKEY

THE RUTABAGA PRINCESS

The rutabaga princess had a
very good personality for
a princess. She h

THANK YOU DOCTOR
middlesworth for saving
my LiFE

I LOVED YOU ONE
SECOND BEFORE I
WAS BORN AND
I WILL LOVE
YOU ONE SECOND
AFTER I DL

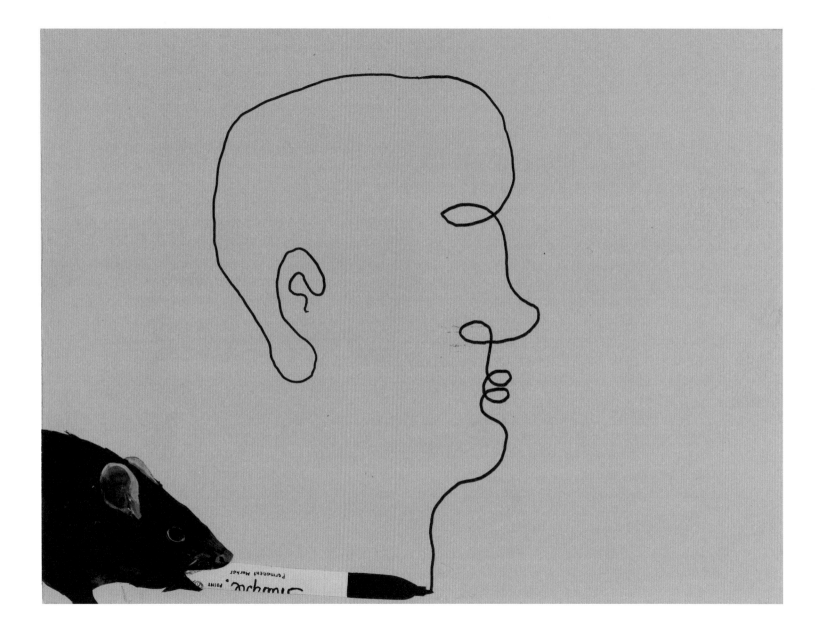

Reasons to Live

1. my children
2. work to be done
3. Flowers
4. Love
5. Transcendence

Reasons not t

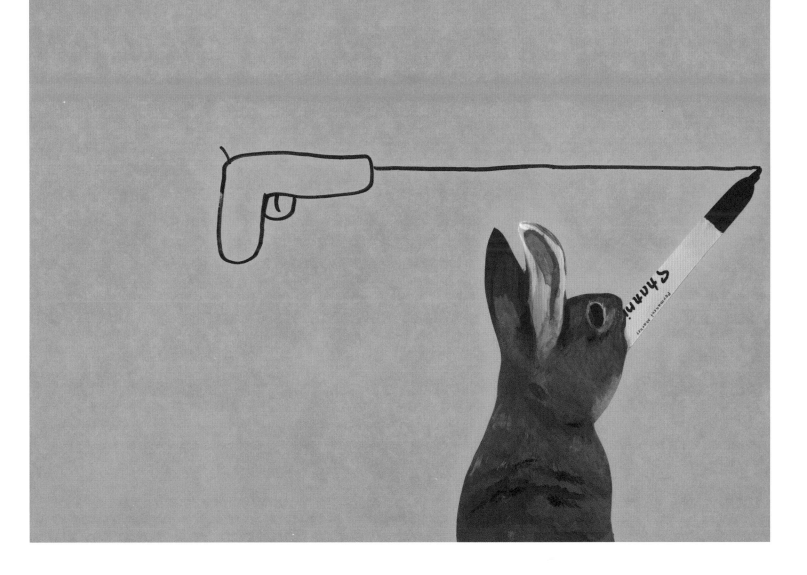

chairplane

fuck swearplane

bear plane

Jane eyreplane

MENU

SHItty HAMbugars - $5
Franch Fries - $2
Ranch drESS

Baby unHOOK Your Jaw I waNNa crawl right INSIDE YOU

Dear Grandma,
You are too
boring

I was walking through the forest with my buddy Eric, when we come across the most beautiful naked lady you ever saw. I guess she was gonna go skinny dipping or something, but there she was standing tall and prow

MY HEART UNFOLDS LIKE A
highWAY FOR UPON Which MY
friends CA∧

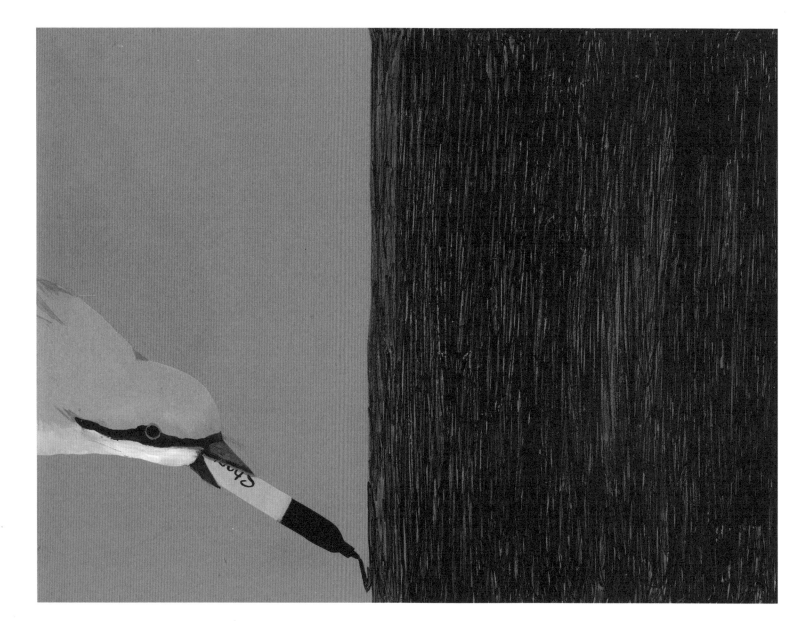

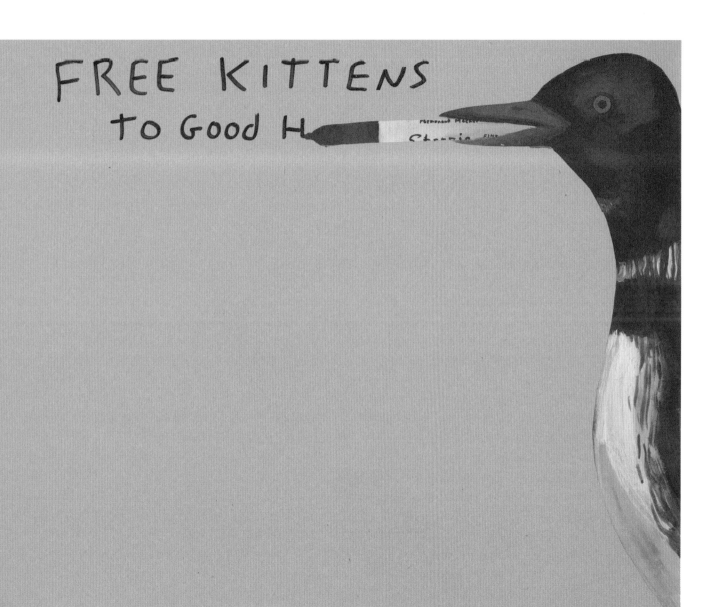

A=A B=ꓷ C=Ɐ D=ꓘ E=B F=ɯ G=ꓭ H=ɯ I=C J=∪ K=Ɔ
L=∪ M=ꓷ N=ꓥ O=ꓷ P=ꓷ Q=E R=ɯ S=Ǝ T=ɯ U=Ⅎ V=ꓱ
W=Ⅎ X=ɯ Y=G Z=ꓷ

ꓷꓥꓕ GBꓱɯƎ ꟷꓕꓕB ꓷꓥBƎBꓘ ƎꓘꓕꓥB
ɯꟷBɯB ∩ꓸꓕBꓘ Ɐ ꓷꓱ∪Ɔꓕ Ⅎɯꓷ ꓕ∩Ⅎ
ꓷꓥɯɯƆBꓘ ɯꓷ ɯꟷB ꓷꓷƎꓷ

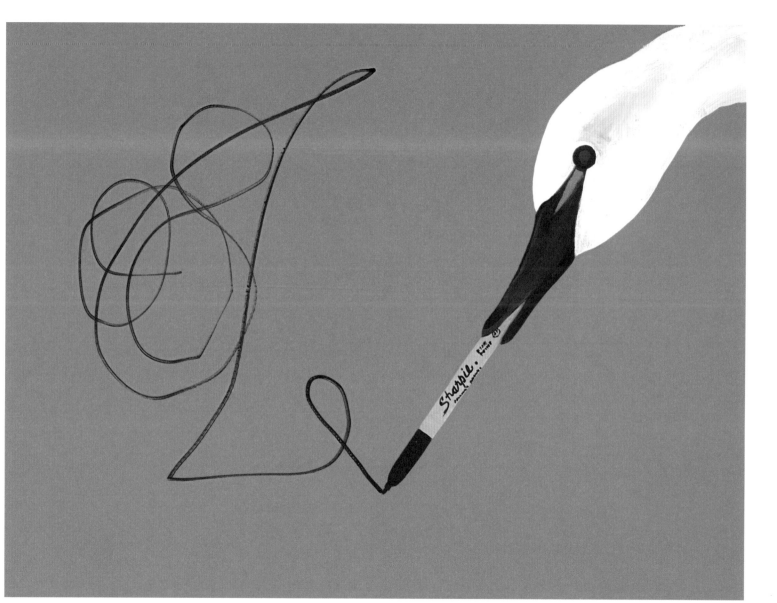

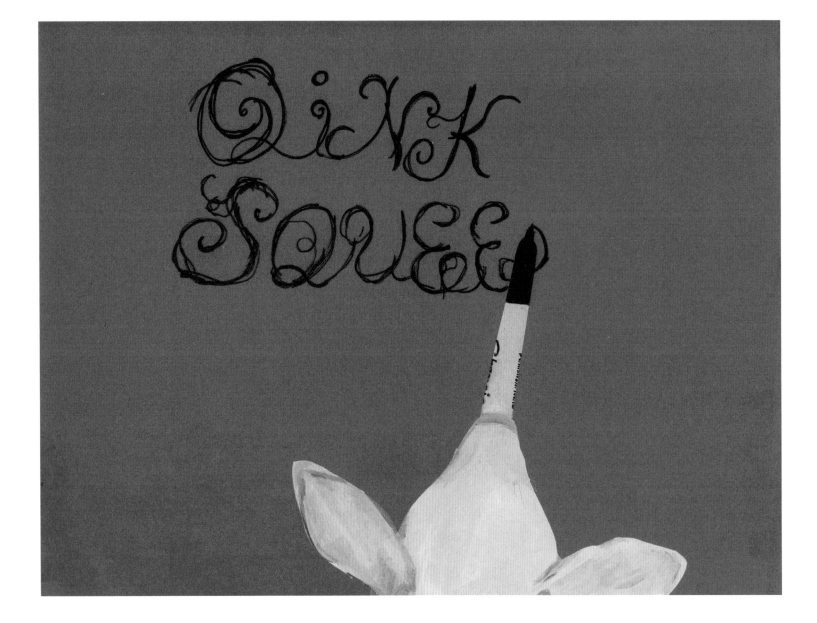

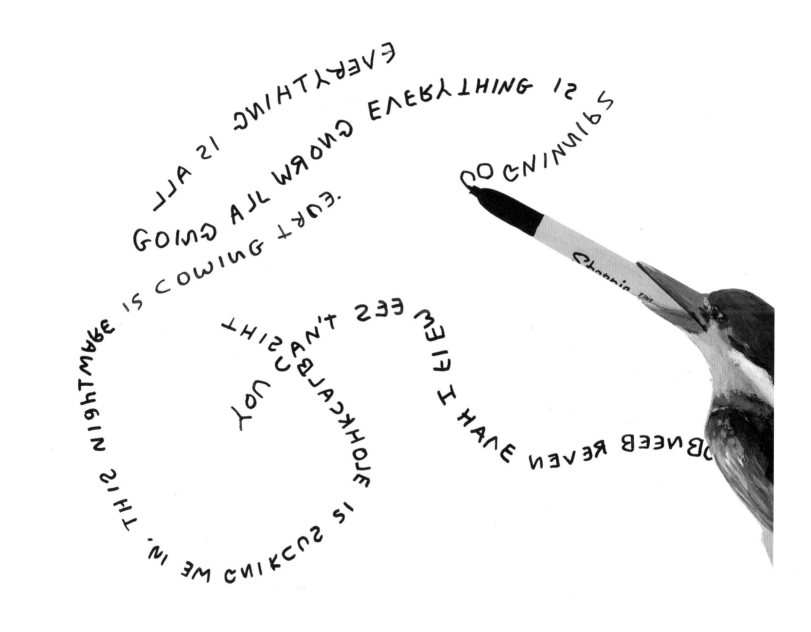

WE ATE AT THE GARBAGE
BEHIND tha PIZA RESTORANt
IT WAS C

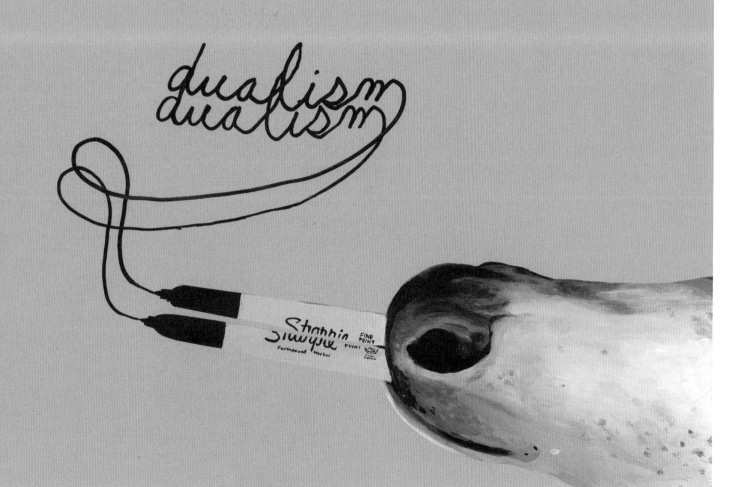

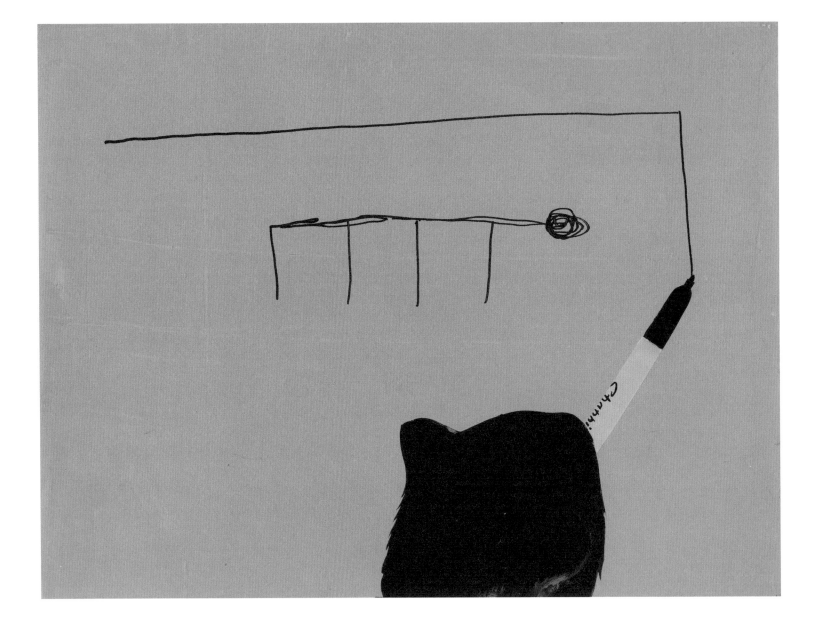

APPLE
BANANA
CANTALOPE
Dragonfruit
ELDERBERRY

LAST WILL AND TESTAMENT

I Roger the Badger bequeath the following items to the following people.

My Good suitcase — Nicky the mule
My Rubber boots — George
My Bible — Riley the Raccoon

My Silver cup — Sarah Goose
My reading glasses — Chauncy
My leather belt — Rory the mole
My Fedora — Lucky the Badger

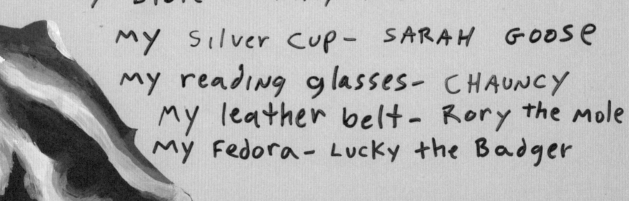

Roger Badger
Oct. 12

I HAD THIS BOYFRIEND OF MINE we've been together ALMOST three years NOW AND He Just Dumped me just like that he told me that I am a no good For Noth

The dog sure barfed

There was a dog and he sure barfed. He was a regular dog except he walked pretty slow. Well

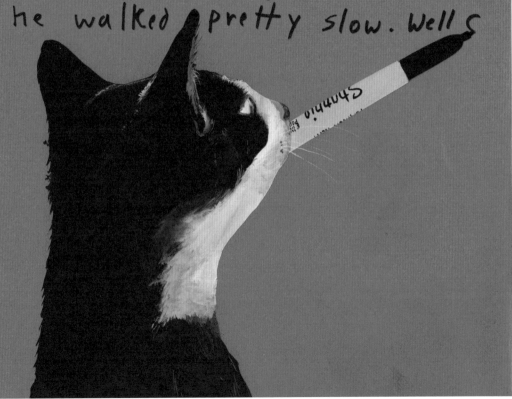

How to spell words using extra Letters

LAMBP

ELIMINATITION

Whistfull

IRRADDIATTIONN

BOUOQUET

CHRONICKLE

AVAILAIBL

PENCIL OF AUTOCUBE OF
The block OF the JAket OF
the houze OF fire too
The OF A GIE∼t big
Suit BUeket for MY
ov zuprised GO

Tailles différentes de boîtes dans le
Système international d'unités.

18.26 mm	17.46 mm	16.67 mm	15.87 mm

19.05 mm	20.64 mm	22.22 mm	23.81 mm

38.10 mm	34.92 mm	

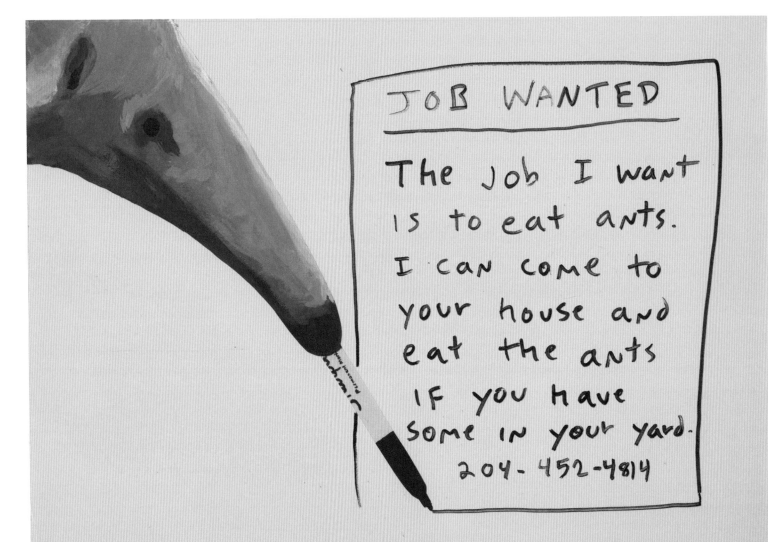

We entered the field
and sat down. Everything was
coming at me the forest was
a wall of sound breathing in and
out translucent musical notes Floated
here and there this was meant to
be always si

ACORUS vulgare, Verspertillionis Sanguinem, and Solanum somniferum are boiled together in oil. To this is added Indian Hemp and stramonium, and finally the blood and fat of Night birds to bind it into an ointment.

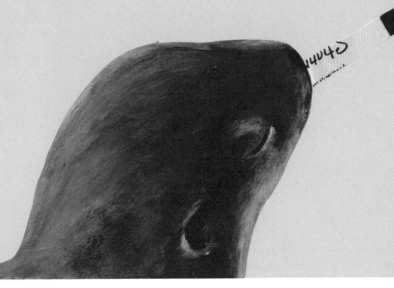

MARRY HIM	DON'T MARRY HIM
Keep An eye on him	Someone better might come along
not getting any younger	he's one taco short of a combination plate
he does lots of push ups	he talks very loudly
Nice ears	

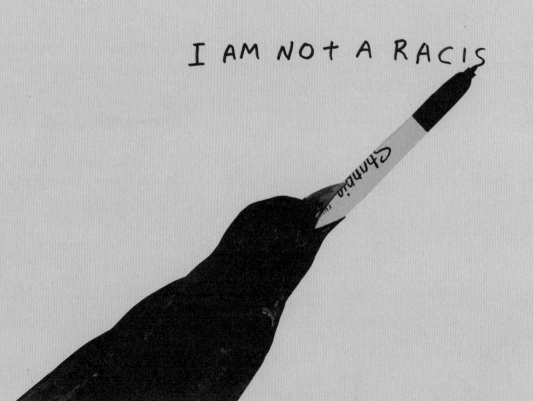

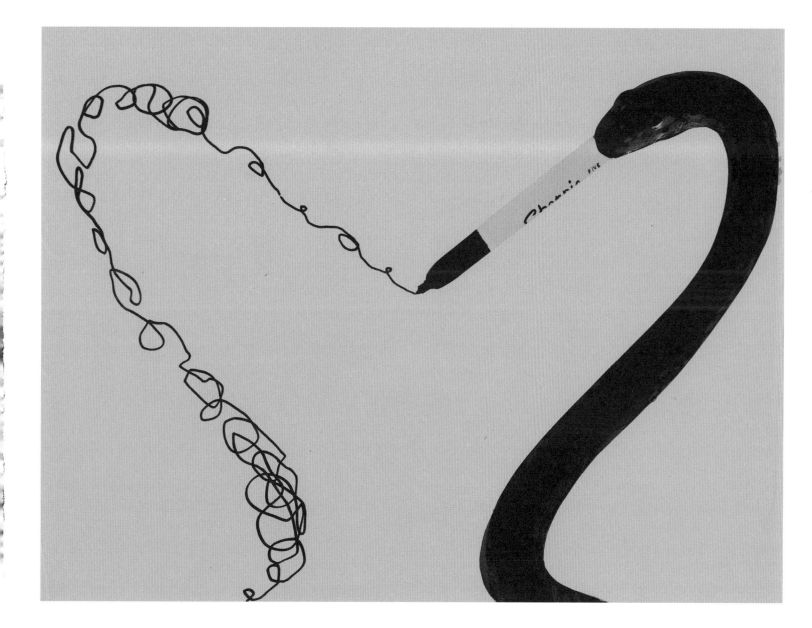

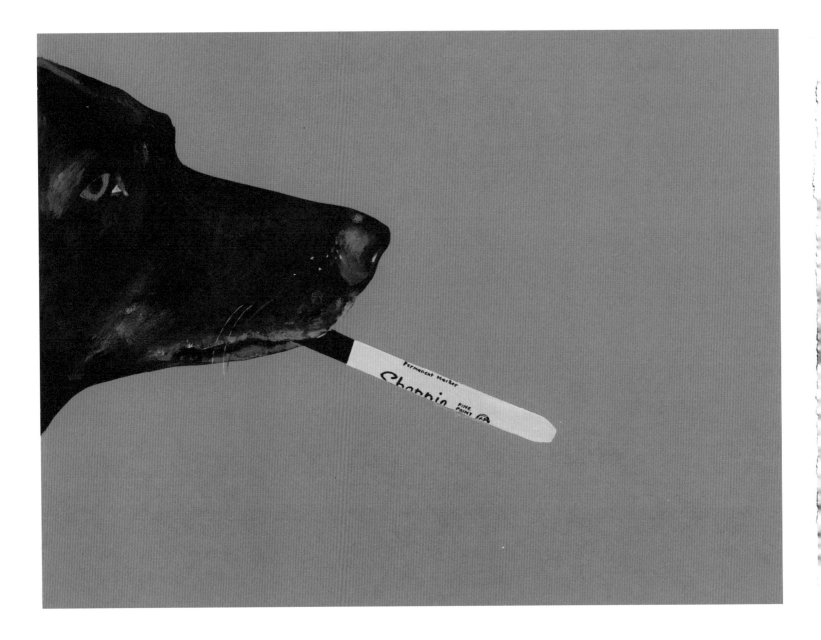

Michael Dumontier and Neil Farber met while studying at the University of Manitoba. In March 1996, they helped found the Royal Art Lodge collective and remained active members until the group disbanded in 2008. Since that time, they have continued to work together, meeting once a week to make collaborative paintings. At the same time, Michael and Neil maintain their own independence. They live and work in Winnipeg, Manitoba. Their first book with Drawn & Quarterly, Constructive Abandonment, *was published in 2011.*